Sasquatch's BIG HAIRY DRAWING BOOK

BY CHRIS McDONNELL

CHRONICLE BOOKS

SAN FRANCISCO

MANUFACTURED IN CHINA.
ISBN: 978-0-8118-7808-1

DESIGN BY CHRIS MCDONNELL

10 9 8 7 6 5 4 3 2 1

CHRONICLE BOOKS LLC
680 SECOND STREET
SAN FRANCISCO, CA 94107
WWW.CHRONICLEBOOKS.COM

HI! I'M
THE AUTHOR!

CHECK THIS OUT...

MY NEW
DRAWING BOOK!

I MADE IT
FOR YOU TO DRAW IN!

WANNA KNOW
A SECRET?

I STOLE ALL
THESE IDEAS
FROM SASQUATCH!

HE'S **HILARIOUS!**

YOU BETTER NOT
TELL HIM THOUGH...

I CAN'T HAVE HIM START
THINKING THAT I OWE HIM
ANY OF MY ROYALTIES...

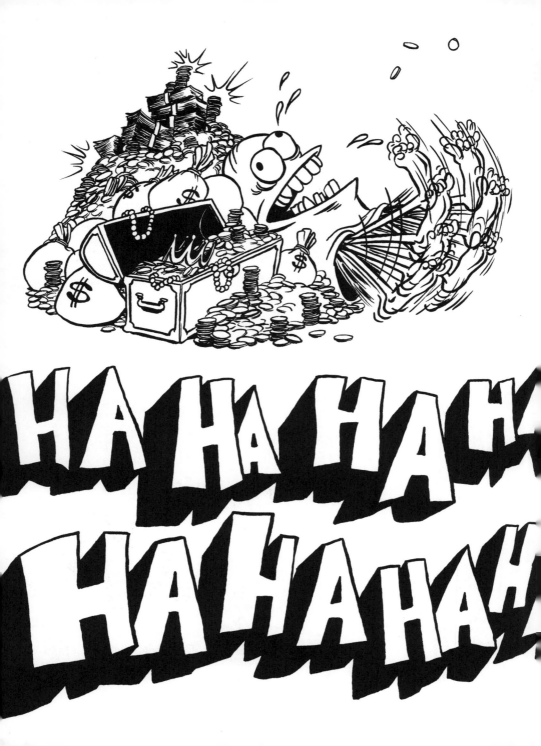

OK.
LET'S BEGIN.

Fill in the top bit.

why why Why did she break up with me

Why is Sasquatch crying?

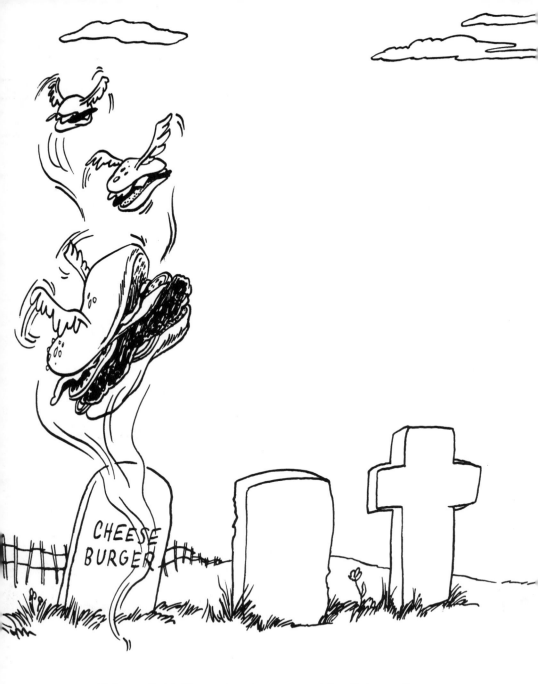

CHEESE BURGER

Help me finish illustrating this graveyard for all the stuff you ate.
Their souls are ascending to Heaven.

I started with some cheeseburgers, because even if you are a vegetarian now, I bet you ate some cheeseburgers as a kid.

"I have really bad skin."

"I have far too many eyeballs."

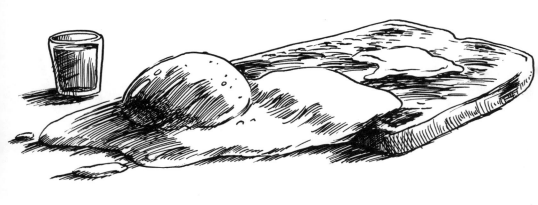

Finish this breakfast scene. Add the breakfast trolls.
(The orange juice is actual size. It's one of those free ones you get with the special.)

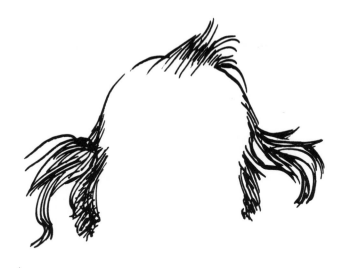

Draw a wonderful person who would appreciate wearing this hairstyle.

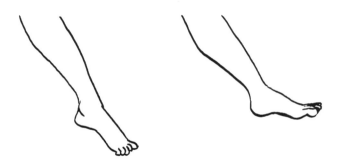

Fill in the middle bit.

Fill in the top and bottom bits.

These gentlemen need you to draw them great hairstyles that will help them to feel self-confident and successful.

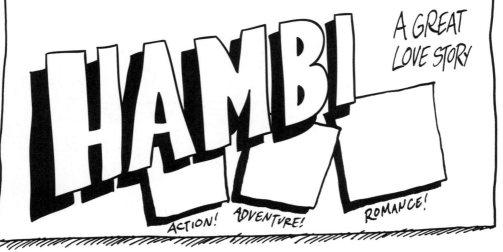

One little ham, destined to become prince of the deli counter, finds love and must lead his friends to safety!

HAMBI

A GREAT LOVE STORY

ACTION! ADVENTURE! ROMANCE!

Finish this movie poster.

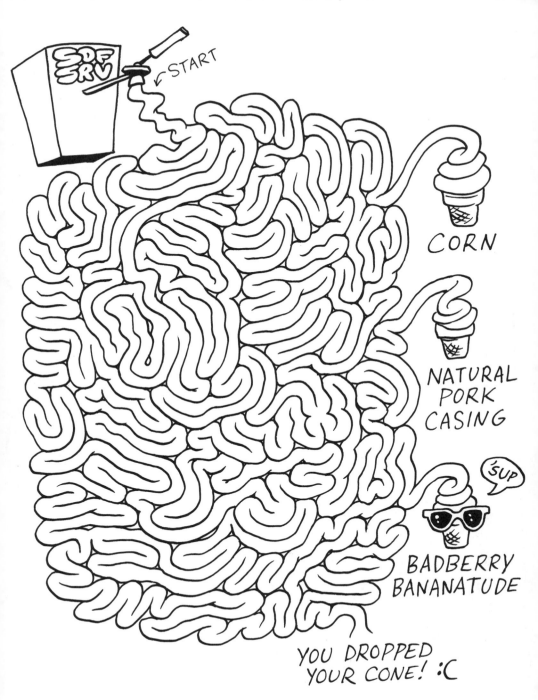

What flavor will you get?

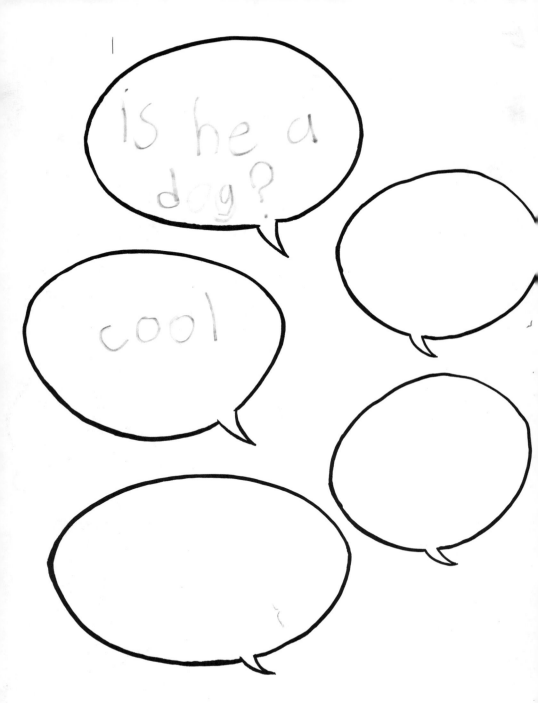

Fill in Dog-E-Biznutz's signature catch phrases.

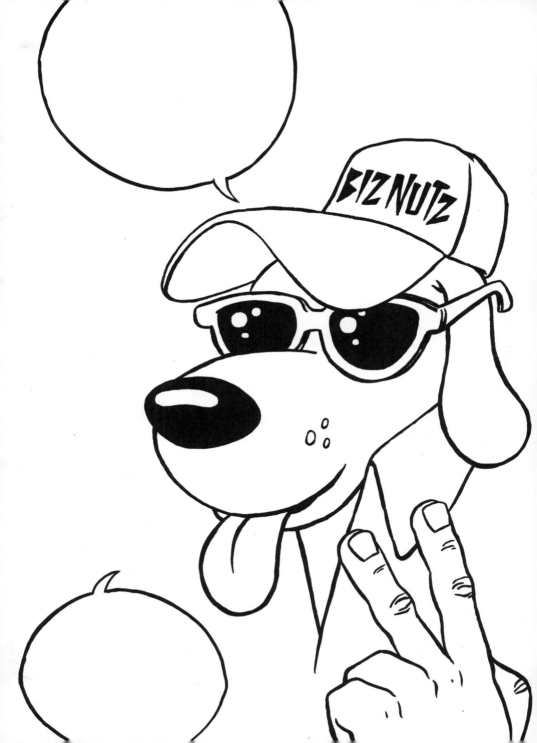

This proboscis monkey is extremely interested in what you've drawn here.

Draw a wonderful person who would appreciate wearing this hairstyle.

You really shouldn't have received this package at work.

I just tried to look out the window to see the scaffolding these guys are building, but I hit my head really hard on the corner. Draw the mystical vision that I saw here.

You are standing here and are about to receive a gigantic food item
that is so huge that you could live inside of it.
Draw your chosen food item here.

Gross. It's been two weeks in the hot sun now. Imagine the smell. Imagine the clean-up. Why did you bring this into the yard? It's like a beached whale carcass. That is, unless you chose a non-perishable food. Probably not. You probably chose something with a high fat content. Draw the rancid mound here.

Fill in the top and bottom bits.

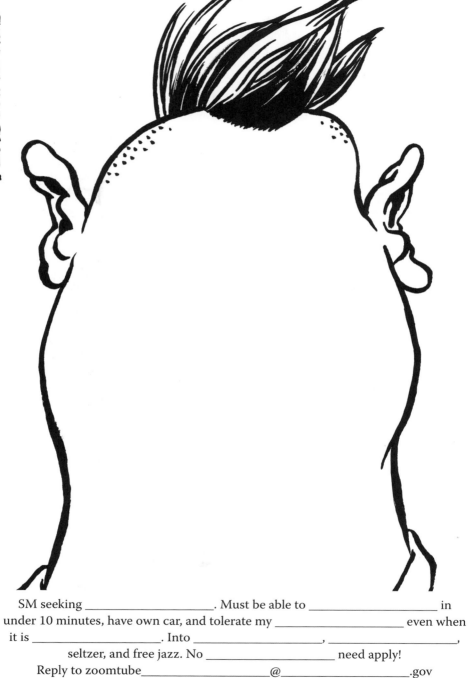

SM seeking _____. Must be able to _____ in under 10 minutes, have own car, and tolerate my _____ even when it is _____. Into _____, _____, seltzer, and free jazz. No _____ need apply!
Reply to zoomtube_____@_____.gov

SWM is searching for a warm female for companionship and
_____. Must be well moisturized and _____.
Likes: Corners, _____, _____,
and dull paring knives. Turn offs: _____,
_____, bruised bananas, and sun exposure. Please reply to
jerrythe_____@_____.com

LARGE DOG

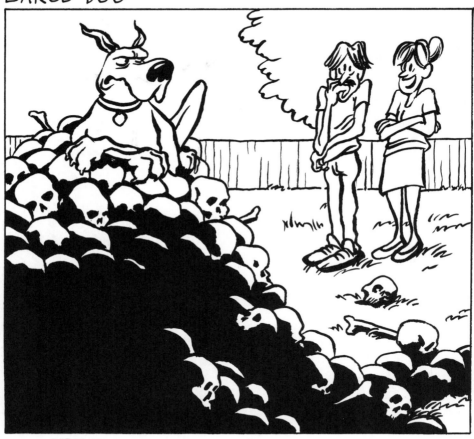

For these single panel comics, you write in the hilarious dialog beneath the panel. When you see empty word balloons on the following pages, fill in the words. When you see empty panels, fill in the drawings.

PAGES

SAD MAN

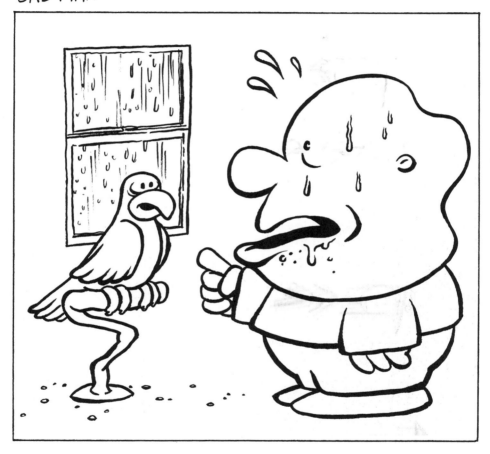

Honestly, do whatever you want. I can't stop you. It's out of my hands now.

SPAZZY McJANITOR

FACIAL MUTANTS

PETER

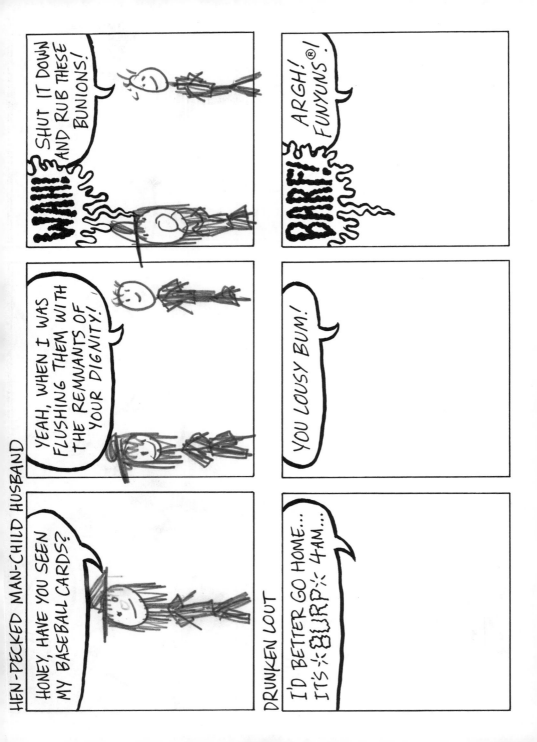

OLD

GACKY

These presidents strongly disapprove of what you've drawn here.

Is going for the deluxe cheeseburger a reward worth the energy and risk?
Or should the ant just hang out at his friend's place and watch the fight?

Let's reflect on this in relation to our own lives.

Draw a wonderful person who would appreciate wearing this hairstyle.

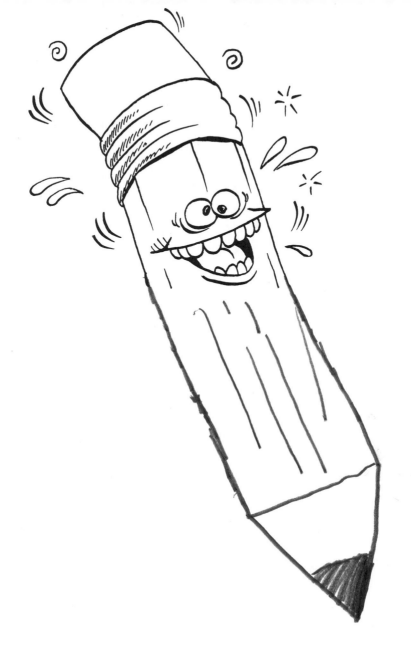

Fill in the bottom bit.

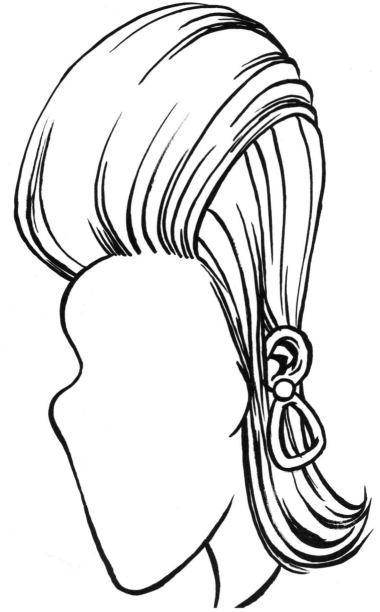

SWF, convenience store clerk, hair sculptress, and heir to a vast fortune is seeking a _____ to _____ into my life and help me spend my forthcoming riches on _____ and _____. My terminal disease _____ will surely claim me before long, so let's get _____ and hope that grandpa goes before I do. Reply quickly to miss_____@ _____.com

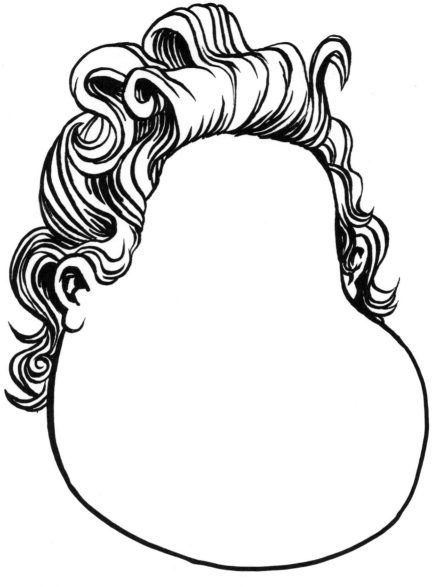

Single _____, is seeking a _____
for _____ and comic book reading parties. Must
know a lot about comics and also it wouldn't hurt if you also collected
_____ like I do. My collection is actually the premier collection
on the Eastern seaboard. I _____ with it every day and
_____ amongst it every night. You must not touch me. Reply to
zontaraxx_____@_____.com

JUST FONDUE IT

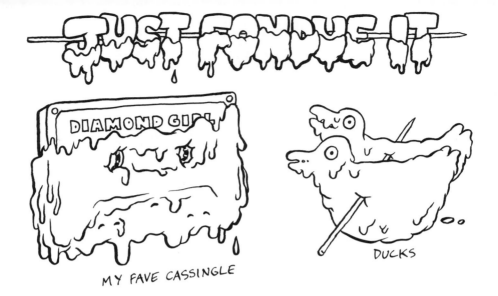

MY FAVE CASSINGLE

DUCKS

Fondue is great because sometimes it's chocolate and sometimes it's cheese
and all your favorite stuff gets even better when you dunk it in.
Draw some of your favorite stuff dipped in molten goo, and possibly skewered.

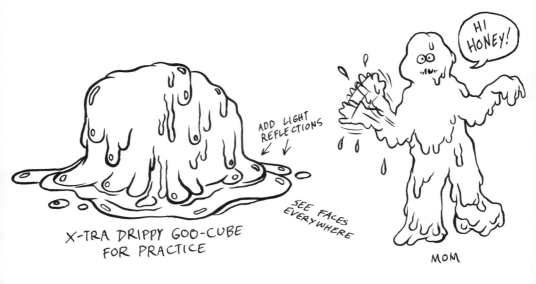

ADD LIGHT REFLECTIONS

SEE FACES EVERYWHERE

X-TRA DRIPPY GOO-CUBE FOR PRACTICE

HI HONEY!

MOM

This bunny is kind of peeved about what you've drawn here.

Finish drawing this proud warrior.

Now draw his main rival for winning the love of the Chief's daughter.

One little clam filters sea water through his inhalant siphon, across his gill cilia, through his labial palps, toward his mouth.

Clambi

The Prince of the Sea

Finish this movie poster.

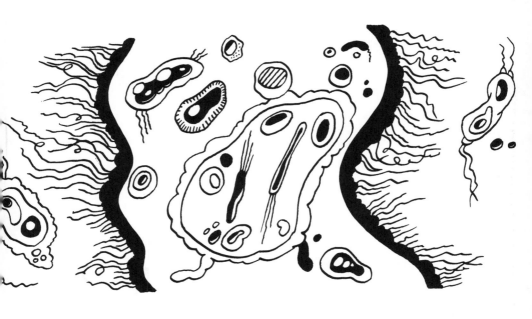

Fill in the top and bottom bits.

Fill in the middle bit.

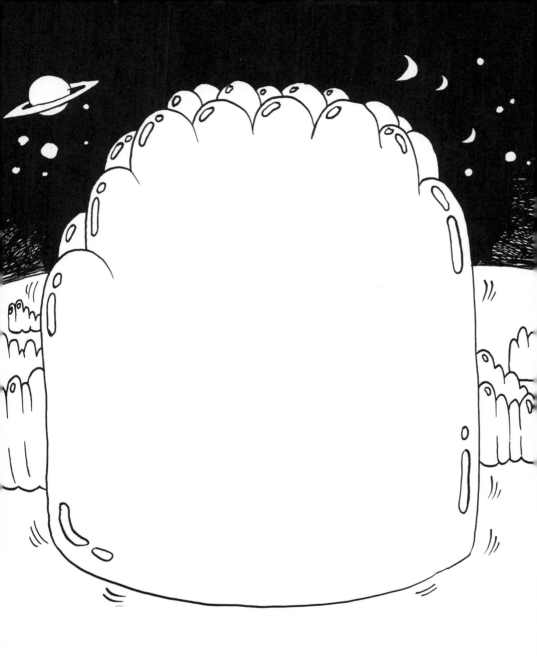

You're trapped inside a gelatin mold (again). Draw yourself eating your way out, despite your extreme gelatin allergy.

Draw some wonderful men and women who would appreciate these hairstyles.

Finish Pop Pop.

Finish Pop Pop's special friend.

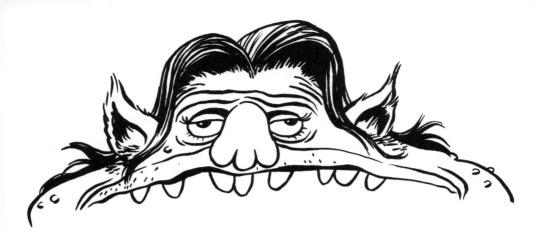

Wanda's portrait needs to be finished.

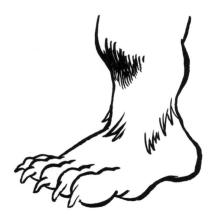
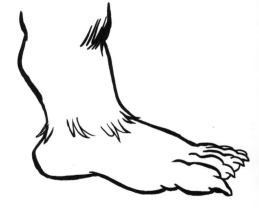

Finish drawing Reggie too.

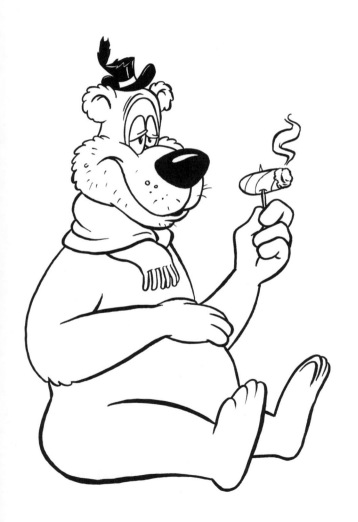

This hobo bear needs some campfire pals.

Meow meow _____ meow mew purrrrr meow
_____. Meow meow _____ meow mew purrrr
purrrr hisssssss. Reply to Mr_____@_____.org

SM is seeking a chick with _____, and a ton of spunk. You gotta
keep up with me out on the town. I love to _____ in the clubs
and _____ with my buddies. You would be one of the guys until
I get you _____ in my _____ and BOOM! We
all know what happens next: _____! You gotta be at least 6 foot,
_____, and dress like a _____. Classy broads only!
 Reply to doctor_____@_____.edu

Let's draw different ducks.

These gentlemen need you to draw them great hairstyles that will help them to feel self-confident and successful.

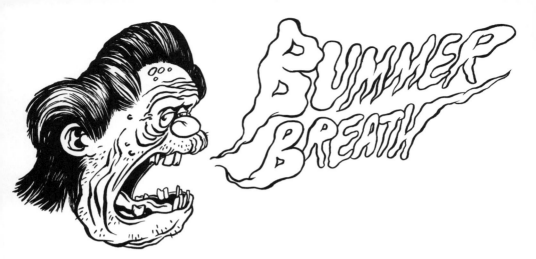

BUMMER BREATH

BOOZE

49 YEARS
OF DENTAL
NEGLECT

SACK OF DAYS
OLD DUMPSTER™
DOUGHNUTS

CHICKEN BONE

MORE
BOOZE

PIGEON

CAN OF

POTTED
MEAT

Food that gives you foul breath: a collection. Draw more
filthy food that will really give you a killer case of halitosis.

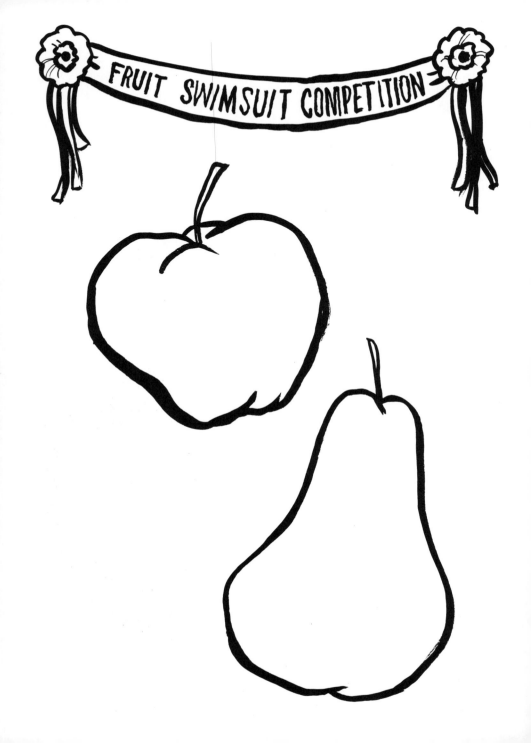

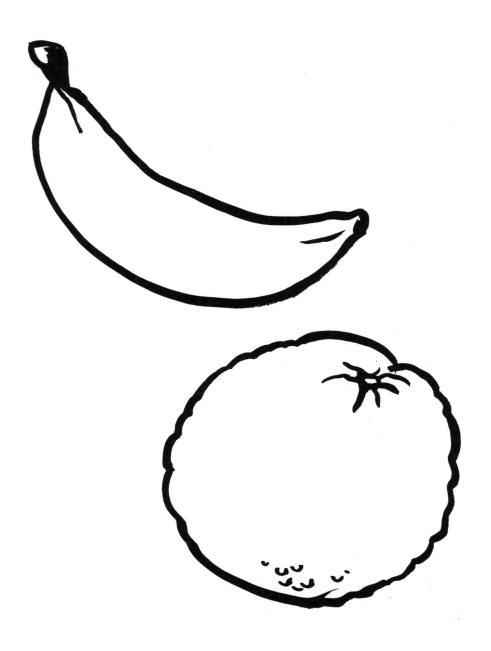

It's competition time! Please dress the fruits in their swimsuits.

Fill in the top bit.

Finish this movie poster.

"UGH! What did I eat last night?"

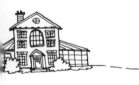

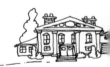

"Help design our mansion. We're filthy rich!"

"Now design our robot. (Make it a lady robot!)"

"Mommy! That guy's head is weird!"

Draw that guy's weird head.

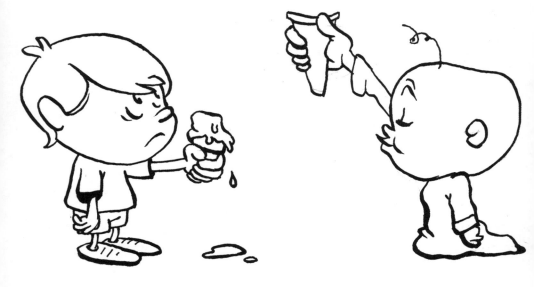

Baby's cone is better in many ways.

What is about to go down here?

GOO TUBES

THE OL' "SOFT SERVE" LOG.

THINK ABOUT THE WRAP-AROUND IN SPACE.

MORE OF A LOW SIDE VIEW.

STUFF DOESN'T ALWAYS COIL NEATLY...

GROUND YOUR LOG WITH SHADOWS.

YOU WANT IT SHINY? WHY NOT.

WHATTA MESS.

YOU CAN *Write* WITH THIS
STUFF TOO. HOW'S YOUR CURSIVE?

Practice drawing your goo tubes.

"More eyes, please."

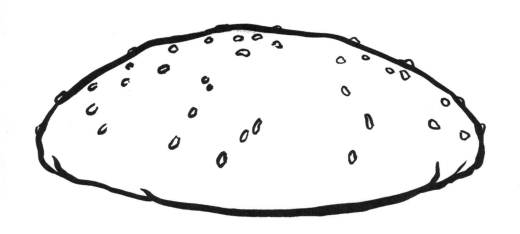

I'm counting on you to draw something unexpected between my buns.

SPACE WIND

SPACE WAR

YOUR GUYS

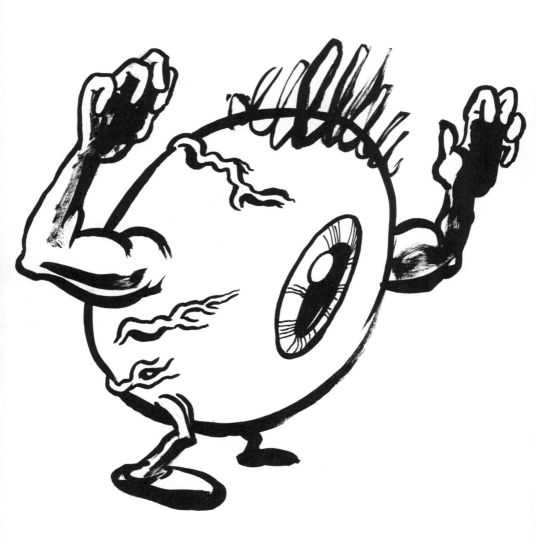

Hand to hand combat. Enemy guy.

Your guy. FIGHT!

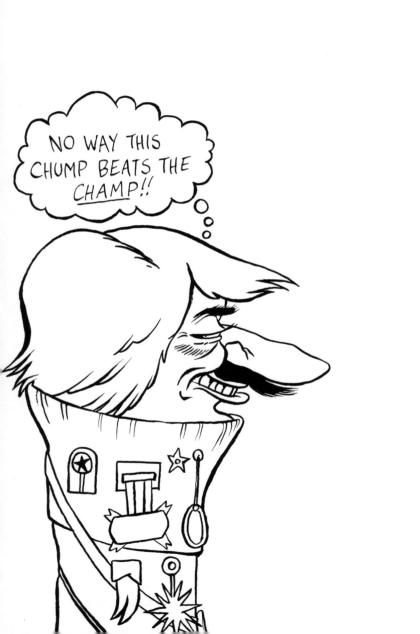

Draw some turtlenecked people that put this turtleneck champ to shame.

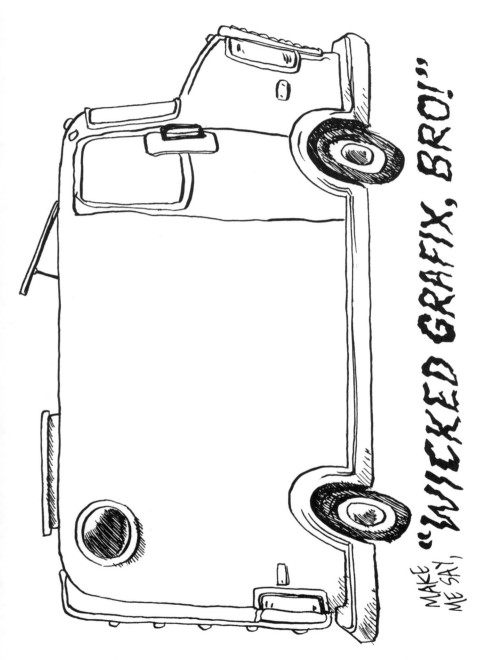

MAKE ME SAY, "*WICKED GRAFIX, BRO!*"

These vans need to be decorated with your primo artwork
so that we can cruise the strip in style.

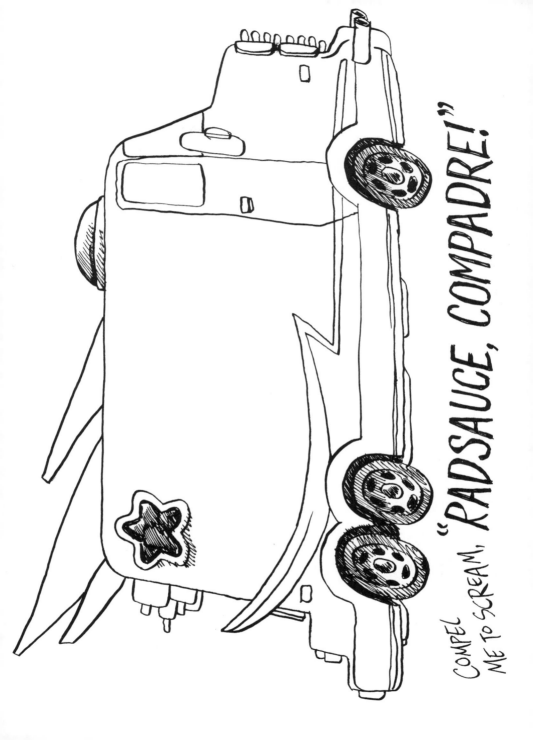

COMPEL ME TO SCREAM, "RADSAUCE, COMPADRE!"

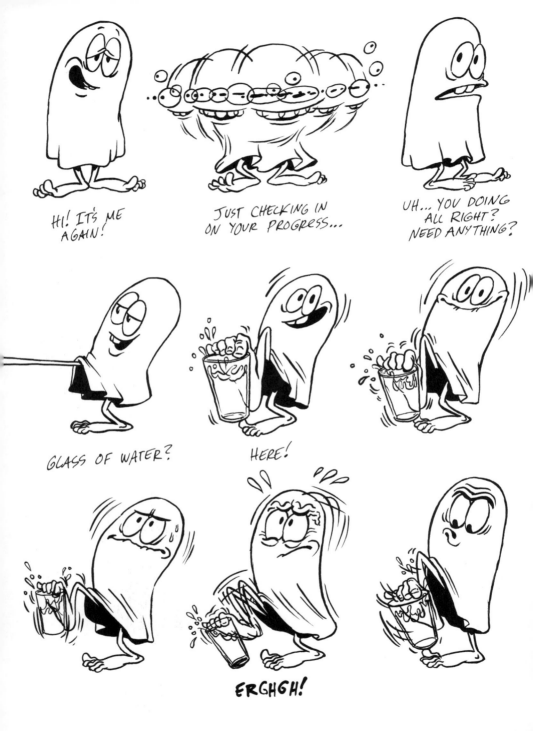

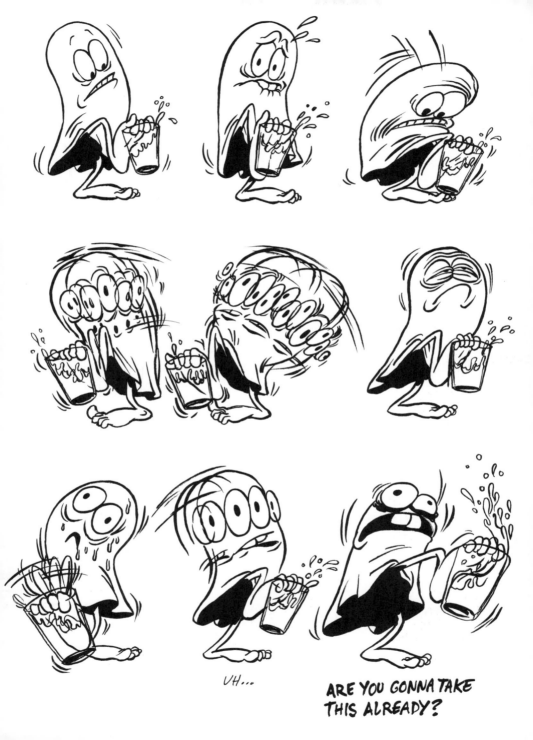

UH...

ARE YOU GONNA TAKE
THIS ALREADY?

Draw all of the massive microbes on your glass, in the water, and everywhere.
Name them all Vanessa and Peter.

Draw the fungi forest on and around my foot.

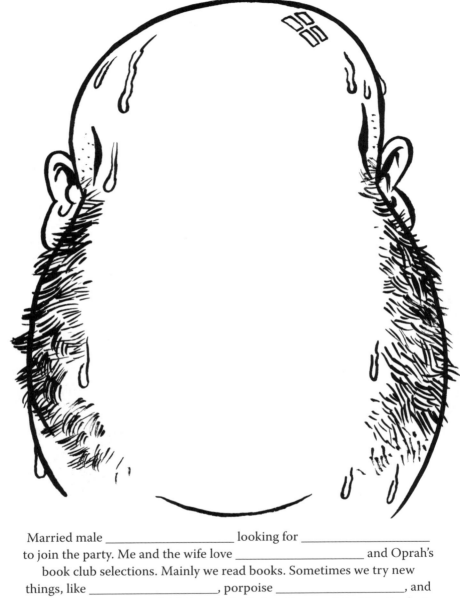

Married male _____ looking for _____
to join the party. Me and the wife love _____ and Oprah's
book club selections. Mainly we read books. Sometimes we try new
things, like _____, porpoise _____, and
_____, which is technically legal in our state, btw. I'm losing
about _____ pounds a week so I don't know how heavy
I'll be when I meet you. Just imagine me as a _____ sized
_____, gently marinating in a _____ sauce,
glazed to perfection. Delicious! The wife, however, is unremarkable. Reply to
jeanpierre_____@_____.com

SF is searching for soul-mate. My best physical characteristics are
_____, _____, and _____ in
that order. My psychic landscape is however where we will connect on a higher
level. You must have an impressive _____ and sense of well
being in order to lock into the vibrations of my _____. My
crystals already predict that the person of my dreams is _____
as I type this. I can already _____ it from here. Reply to
rainbowmusic@_____.net

NUT WITH BUGS
AND WEBS IN IT
INSTEAD OF NUT
MEAT

 LAST JANUARY'S
HEATING BILL

RABID CRITTER

Add your worst fears to this handy worst fears collection.

ALIENS GHOST ALIENS

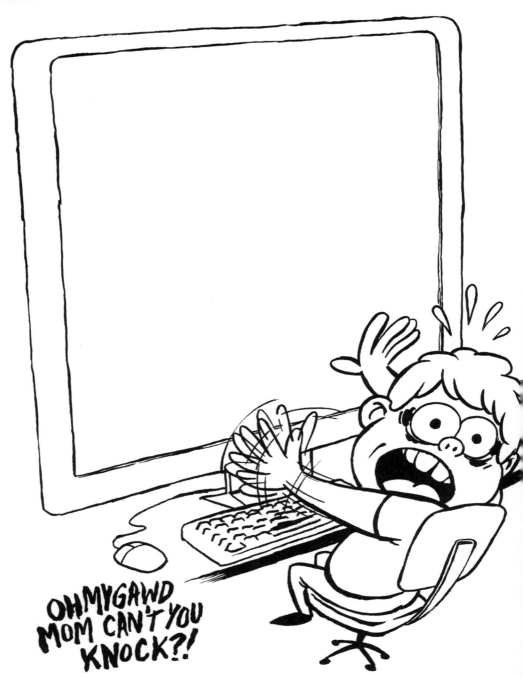

OHMYGAWD MOM CAN'T YOU KNOCK?!

You get a gold star for cleverness if you draw something that is not dirty on Timmy the Teen's computer screen.

Draw a wonderful person who would appreciate wearing this hairstyle.

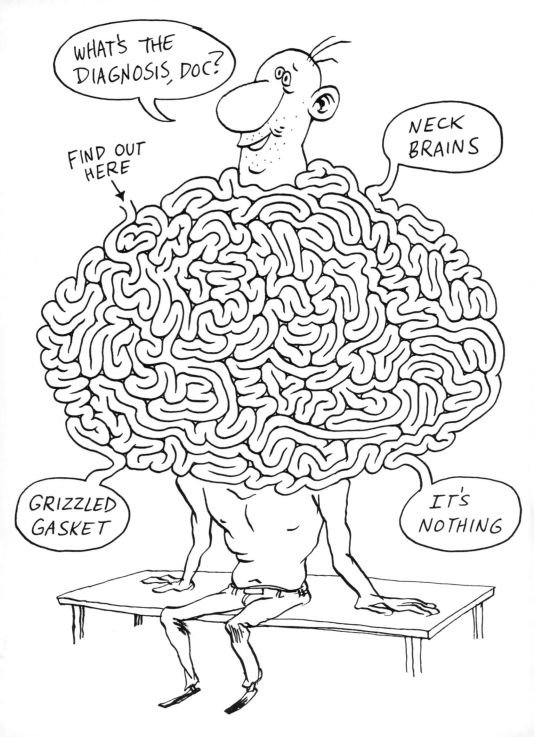

ONE LITTLE DEER'S RISE THROUGH THE RANKS OF HIS LOCAL BACKYARD WRESTLING ASSOCIATION LEADS TO GLORY... AND TRAGEDY... AND **SLAMDIMONIUM!**

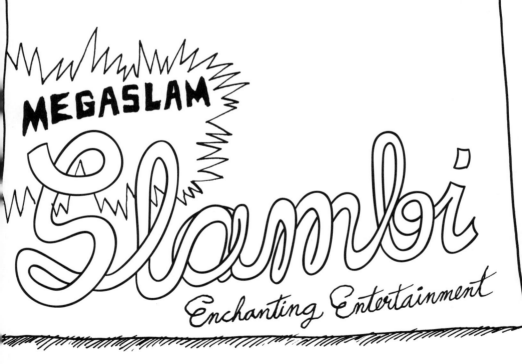

MEGASLAM

Slambi

Enchanting Entertainment

Finish this movie poster.

You have become a wizard of intense power. Draw the first powerful thing you will do here.

OH DANG... IT'S THE
APOCALYPSE!

SPECIAL OCCASION
SANITARY SHEETS

Stuff that becomes more valuable after the apocalypse: a collection. Draw more things here to help remind you what to pack when the time comes.

USED BIRTHDAY
CANDLE

CULTURAL
DOCUMENTS
OF THE PAST

UN-MUTATED
REPRODUCTIVE
MATERIAL

Why is Sasquatch moping?

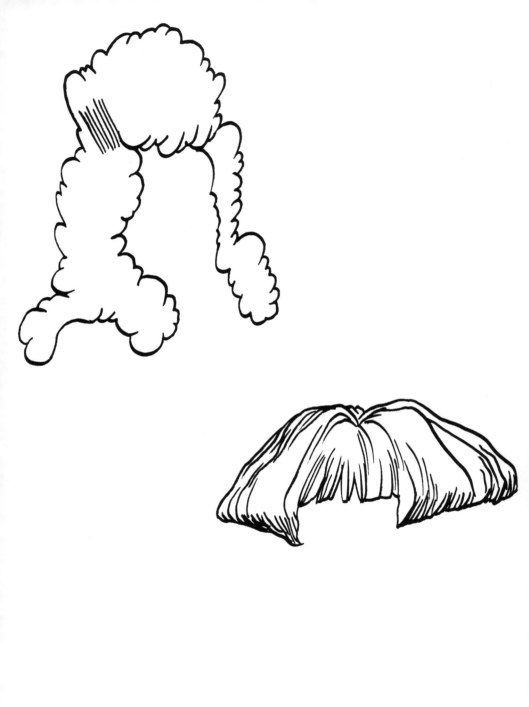

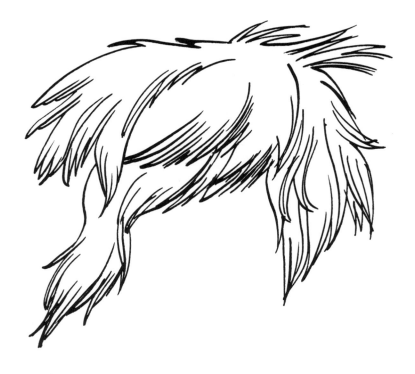

Draw some wonderful men and women who would appreciate these hairstyles.

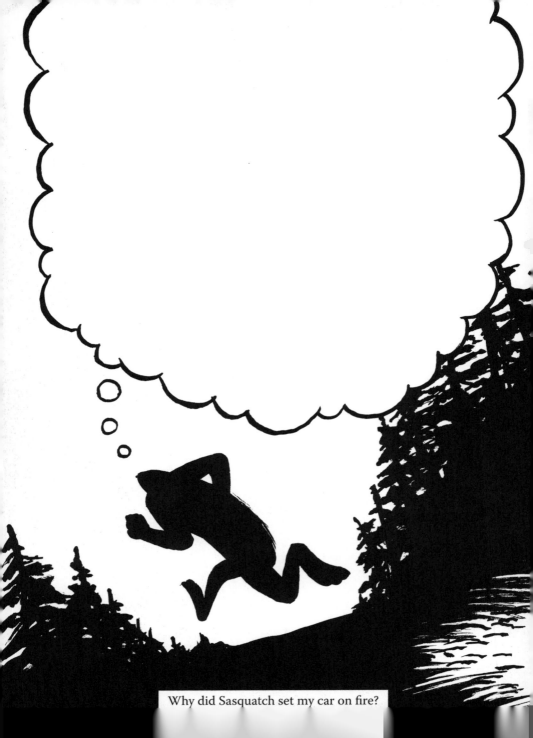

Why did Sasquatch set my car on fire?

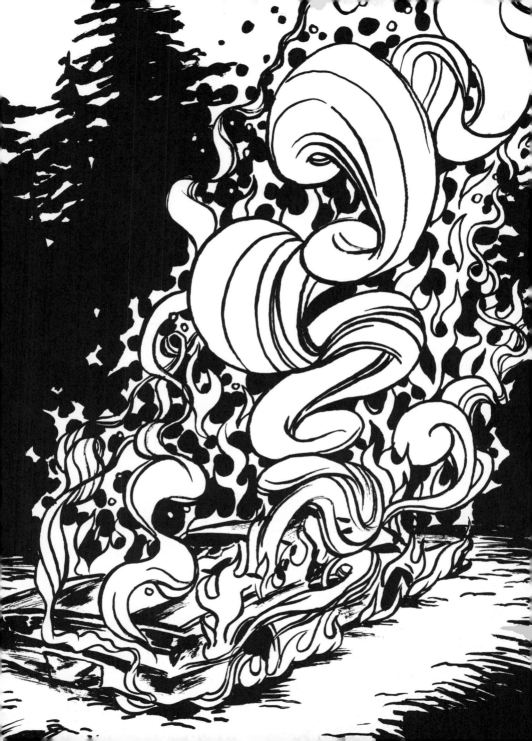

Fill in the top and bottom bits.